illiam Morris was a man of extraordinary diversity and application, turning his attention to the mastery of as many skills in one lifetime as most men would achieve in several. He became an artist in oils, stained glass and ceramic tiles, a weaver, decorator, textile designer, calligrapher, type designer, typesetter, bookbinder, printer, novelist, poet and lecturer. One of his most influential concepts embraced the 'small is beautiful' ideal: *suppose people lived in little communities ... and had few wants; almost no furniture for instance, and no servants, and studied ... what they really wanted.* Then, Morris felt, life might begin to take on its proper form. He was unquestionably one of the first conservationists. Certainly, a century later, his ideas and his designs are still valued and enjoyed by people everywhere.

His first study was architecture, which he regarded as *the foundation of all the arts.* Although he spent less than a year studying it he described it as embracing *the whole external surroundings of the life of man; we cannot escape from it if we would so long as we are part of civilization, for it means the moulding and altering to human needs of the very face of the earth itself ...; it concerns us all, and needs the help of all,* down to the smallest decorative detail. The breadth of this conception made Morris's ideas important since most of them sprang from it. Architecture was followed by the design of household furniture and furnishing: *Have nothing in your houses that you do not know to be useful or believe to be beautiful.* Perhaps surprisingly, Morris did not design much successful furniture, but he did design the general schemes of decoration for Morris & Co. for 25 years, and supervised the production of their furniture.

Pattern-making was felt by Morris to be an integral part of decoration and furnishing in tiles, wallpaper textiles and stained glass as practised by the medieval craftsman, *who knew his work from end to end, and felt responsible for every stage of its progress.* Examples of all these may be seen in a variety of fine buildings all over England, and many are mentioned in this book.

Morris became interested in calligraphy and his first printing projects were for illustrated editions of his own poems, *The Earthly Paradise* and *Love is Enough.* Later he set up the Kelmscott Press which enabled him to express his enthusiasm for typography and printing as arts in their own right.

In addition to the decorative arts for which Morris is now so well-known, in his own time he was probably better known as a poet and prose writer of novels and Icelandic saga translations. As he grew older Morris's interest in politics developed. One result of this was that he founded the Society for the Protection of Ancient Buildings. *I have more than ever at my heart the importance for people of living in beautiful places; I mean the sort of beauty which would be attainable by all, if people could but begin to long for it.* He founded too the Socialist League, one of the forerunners of the modern Labour Party.

Small wonder that a doctor said of William Morris's death in 1896: 'the disease is simply ... having done more work than most ten men'.

We owe it to William Morris that an ordinary man's
dwelling house has once more become a worthy object of
the architect's thought, and a chair, a wallpaper, or a vase a
worthy object of the artist's imagination.
Nikolaus Pevsner

 was born at Walthamstow ... a suburban village on the edge of Epping Forest and once a pleasant enough place, but now terribly cocknified and choked up by the jerry-builder.

My father was a business man in the city, and well-to-do; and we lived in the ordinary bourgeois style of comfort ...

I went to school at Marlborough College, which was then a new and very rough school. ...but the place is in very beautiful country, thickly scattered over with historical monuments, and I set myself eagerly to studying these and everything else that had any history in it, and so perhaps learned a good deal, especially as there was a good library at the school to which I sometimes had access. I should mention that ever since I could remember I was a great devourer of books ...

My father died in 1847 a few months before I went to Marlborough; but as he had engaged in a fortunate mining speculation before his death, we were left very well off, rich in fact.

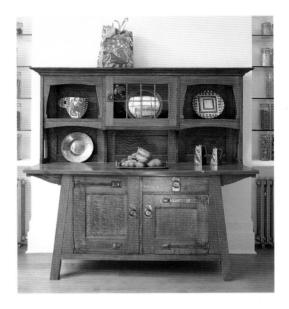

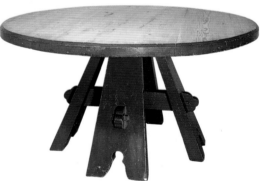

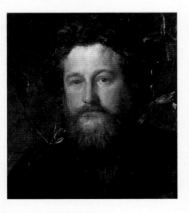

ABOVE:
This great round table 'as firm, and as heavy, as a rock', designed by Morris for Red Lion Square, and described by Rossetti, is now in Cheltenham Museum.

LEFT:
William Morris at 37, by G.F. Watts, painter of the Victorian great and good.

TOP:
Oak sideboard from Liberty. This piece of furniture, made after Morris's death, is a commercialised reflection of his inspiration for his vision of the Arts and Crafts movement, found in the simple, sturdy 'carpenter's furniture' seen in Oxford's University Museum.

While still an undergraduate, I discovered that I could write poetry, much to my amazement.

Morris went up to Exeter College, Oxford, in 1853. He disliked it, but met Edward Burne-Jones, who became a lifelong friend, and through him, in London, Dante Gabriel Rossetti. Both were painters and under their influence he decided to become an artist rather than take holy orders as his mother had intended.

Morris, Burne-Jones and William Fulford made a visit to northern France in their final University long vacation. The medieval cathedrals, which included Amiens, Beauvais, Chartres, Evieux, Rouen, Bayeux and Coutances, and many cathedral churches that they visited had such a profound effect on Morris that at the beginning of 1856 he signed his articles with G.E. Street, an architect in Oxford. For the first time he met Philip Webb, who was to become one of the founding partners of Morris, Marshall, Faulkner & Co., 'The Firm' that became very popular amongst the intellectual classes of Victorian Britain as a decorating business.

Morris shared shabby rooms in London at 17, Red Lion Square with Ned Burne-Jones after his disillusionment with architecture in the firm of G.E. Street, and set about having some furniture made to his own design. Henry Price, cabinet-maker, recalled, 'A gentleman who in after years became a noted Socialist, and Poet as is an Art Furnisher called at our shop and got the govner to take some orders for some very old fashioned Furniture in the Mideaval Style.'

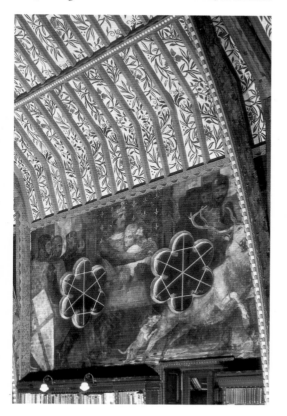

LEFT:
The Oxford Union Murals, 1857. Morris's opinion of his own part in this, in 1869, was not flattering: 'I believe it has *some* merits as to colour, but ... [it is] extremely ludicrous in many ways ... '

ABOVE:
'If I Can' Hanging, now at Kelmscott Manor, was designed and embroidered by Morris for Red Lion Square, using embroidery wools on linen.

3

I cannot paint you but I love you.

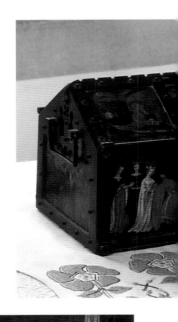

n December 1857 Morris met Jane Burden, the 18-year-old whom Rossetti described as a 'stunner' and whose beauty overwhelmed Rossetti to such a degree that by the time of his death he had painted and drawn her many times. Morris's own attempt to use Janey as a model for *La Belle Iseult* is his only surviving painting, finished in 1858; the message shown above that Morris scribbled on the back of it indicates his conviction that he could not be an artist.

Janey had been born into a poor family in 1839 and spent her childhood in a cramped and insanitary cottage. It is hardly surprising that she accepted Morris's offer of marriage and the security that this well-to-do young man could provide. To Morris, Janey represented

BELOW:
Study for *Iseult in the Ship*, c.1857. A pencil and ink portrait of Jane Burden, which Morris almost certainly drew as a study for mural paintings at Red House in 1861/2.

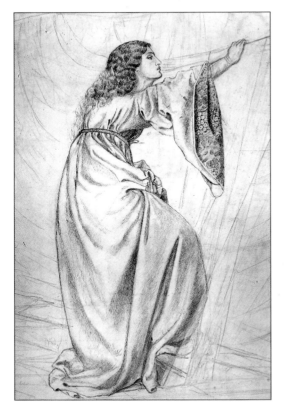

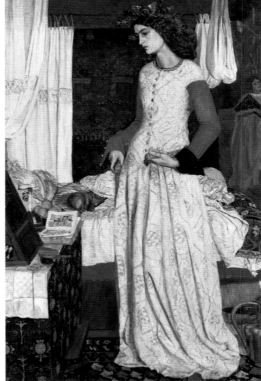

ABOVE:
The jewel casket, probably designed by Webb and painted by Rossetti and Elizabeth Siddal, given to Janey as a wedding present. It is now at Kelmscott Manor, in Mrs Morris's bedroom.

an ideal of female beauty that was quite different from what his 'class' expected. Her unearthly beauty and aloof aura became the inspiration of the Pre-Raphaelites.

A short while before meeting Jane Burden, Rossetti had gathered Burne-Jones and Morris into a second Pre-Raphaelite Brotherhood. In 1848 he had been a founding member of the first Brotherhood, now dispersed.

On 26 April 1859 Morris married Janey in St Michael's parish church in Oxford.

BELOW:
This painted wardrobe was given by Burne-Jones and Webb to Morris as a wedding present. It is now in the Ashmolean Museum, Oxford.

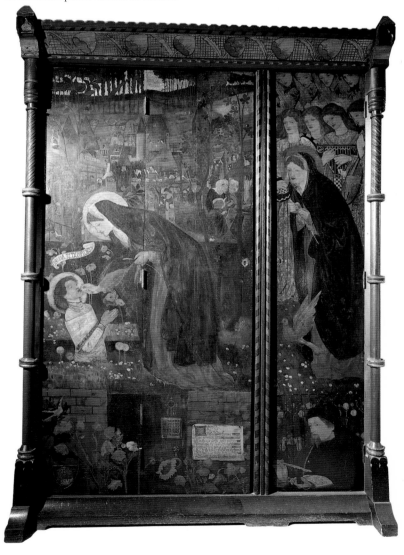

LEFT:
Queen Guenevere or *La Belle Iseult*, 1858, painted by Morris in oil on canvas.

'More a poem than a house': Dante Gabriel Rossetti

ou will see that I have started as a decorator which I have long meant to do when I could get men of reputation to join me, and to this end mainly I have built my fine house.

The *fine house,* Red House, in the village of Bexleyheath, Kent, was designed for Jane Burden and Morris to live in after their marriage by Philip Webb, in close co-operation with William Morris. Dante Gabriel Rossetti's description of it as a poem sprang from his perception of the close emotional bond between Webb and Morris in this work. Decorations and furniture were all carefully chosen and designed for this house which Morris envisaged as a 'house within an orchard'. Later the functionalism of Red House influenced the architects of the 1930s and the close collaboration of Morris and Webb continued until Morris's death.

RIGHT:
A settle, designed by Morris for Red House, although he did not paint it white. It is one example of Morris's criticism of the over-stuffed upholstery of the 1870s, of which he said, 'if you want to be comfortable go to bed'.

BELOW RIGHT:
William Morris designed the 'Daisy' Hanging in 1860 for Red House, and Janey, her sister and friends worked it in wool on serge. It is now in Kelmscott Manor.

BELOW:
The Red House, Bexleyheath, painted by Walter Crane 1845–1915.

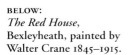

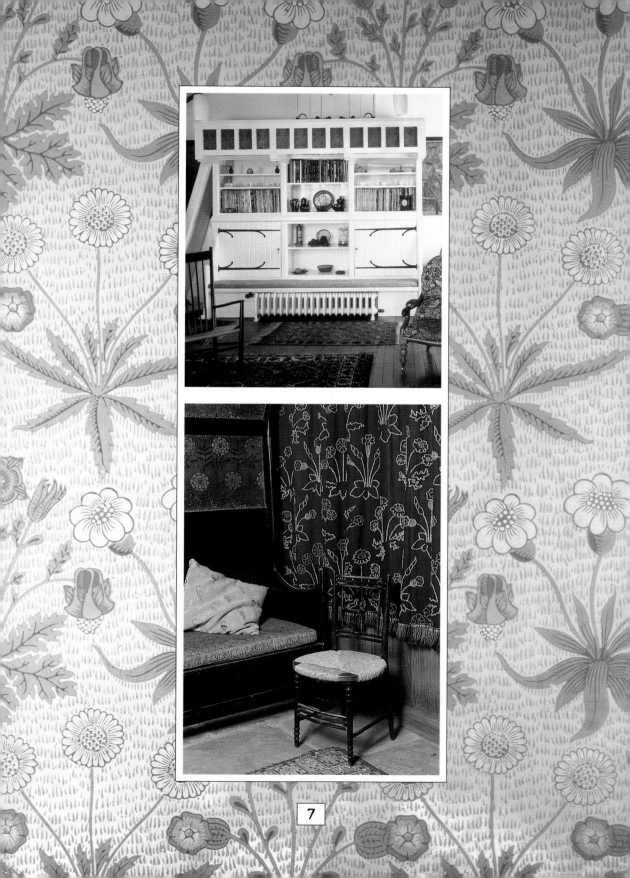

THE FIRM

Ford Madox Brown /
D. G. Rossetti / Edward Burne-Jones
P. P. Marshall / Philip Webb
C. J. Faulkner / William Morris

he growth of Decorative Art in this country, owing to the efforts of English Architects, has now reached a point at which it seems desirable that Artists of reputation should devote their time to it. Although no doubt particular instances of success may be cited, still it must be generally felt that attempts of this kind hitherto have been crude and fragmentary... The Artists whose names appear above hope by association to do away with this difficulty.

BELOW:
One of 13 stained-glass panels by Morris & Co. illustrating *The Story of Tristram*. Morris drew both figures, but Lancelot was based on a Ford Madox Brown cartoon.

RIGHT:
The Library at Speke Hall contains one of Morris's earliest wallpaper designs, Pomegranate, 1864.

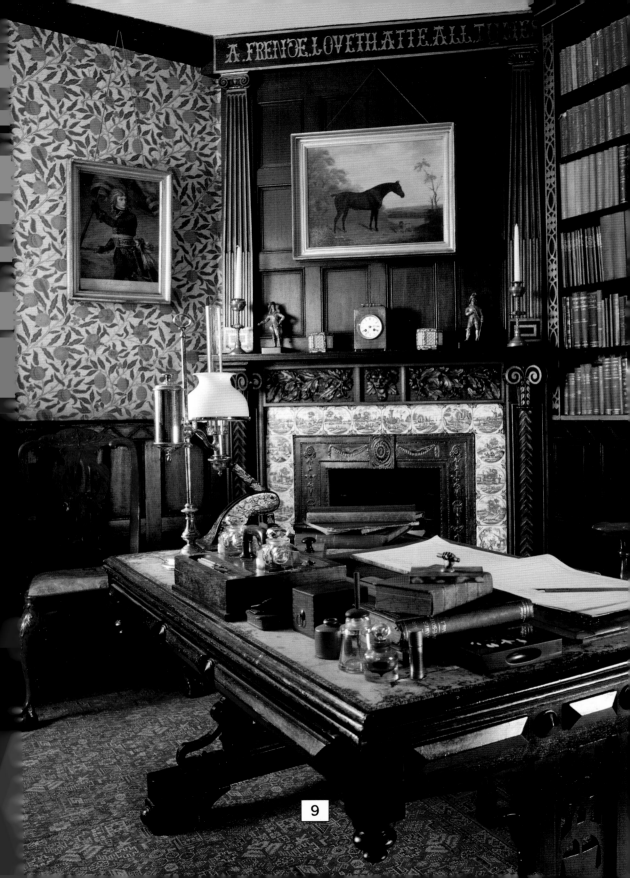

A·FRENDE·LOVETH·ATTE·ALL·TIMES

9

he Firm, whose original name was Morris, Marshall, Faulkner & Co., started business on·11 April 1861 and a prospectus was sent to all those who might become clients. It ended on a very persuasive note:

These Artists having been for many years deeply attached to the study of the Decorative Arts of all time and countries, have felt more than most people the want of some one place, where they could either obtain or get produced work of a genuine and beautiful character. They have therefore now established themselves as a firm, for the production, by themselves, and under their supervision, of:

I Mural Decoration, either in Pictures or in Pattern Work, or merely in the arrangement of Colours as applied to dwelling-houses, churches or public buildings.
II Carving generally, as applied to Architecture.
III Stained Glass, especially with reference to its harmony with Mural Decoration.
IV Metal Work in all its branches, including Jewellery.
V Furniture, either depending for its beauty on its own design, or on the application of materials hitherto overlooked, or on its conjuncture with Figure and Pattern Painting. Under this head is included Embroidery of all kinds, Stamped Leather, and ornamental work in other such materials, besides every article necessary for domestic use.

Families and friends were drawn into the Firm's activities, with wives and sisters sitting alongside their men, painting or embroidering. By the end of 1862 twelve men and boys were developing their talent in the furniture workshops. The men were craftsmen and the boys destitute and untutored. This attitude became one of the chief tenets of the Arts and Crafts movement and foreshadows Morris's later deep involvement in social issues.

 The International Exhibition at South Kensington in 1862, sequel to the Great Exhibition of 1851 which Morris had refused to visit when a youth of 16 or 17, proved a successful venue at which to display the Firm's stained glass and painted furniture, although it was not

without its critics. Coincidentally, 1862 was the year in which Morris ceased to have ambitions to become a painter. He later wrote: *I should have painted well so far as the execution is concerned, and I had a good sense of colour; but though I have so to speak the literary artistic memory, I have not the artistic artistic memory: I can only draw what I see before me, and my pictures, some of which still exist, lack movement.*

LEFT:
These fireplace tiles were executed by William Morris in 1862–4 and are in Queens' College Hall, Cambridge.

BELOW:
Morris painted the panels on this cabinet, designed by Philip Webb, with scenes from the legend of St George. It can be seen in the Victoria and Albert Museum, London.

BELOW:
Cartoon for Artemis, 1861, in Indian ink, chalk and wash on paper, was one of three done by Morris for Red House. It is now in Carlisle Museum.

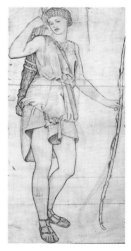

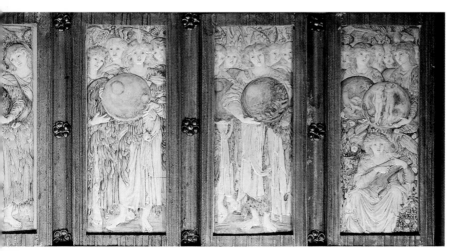

LEFT:
Porcelain panels, made by the Della Robbia Pottery c.1900, were based on paintings by Burne-Jones depicting the 'Six Days of Creation' in Llandaff Cathedral.

In search of The Earthly Paradise 'where none grow old'.

he long narrative poem *The Earthly Paradise* published in 1868 has, like Chaucer's *Canterbury Tales,* a Prologue and 24 stories by different narrators. It earned Morris great popularity as a poet and later consideration as the Poet Laureate successor to Tennyson. (Not only did Morris himself turn down the honour, it is unlikely that the then Prime Minister, Gladstone, would have favoured such an out-and-out Socialist.)

Burne-Jones said of Morris's poetry: 'You cannot find short quotations in him, he must be taken in great gulps.' This must surely go far to explaining the great neglect of this once most-popular poet, in our own age of short sound-bites.

The move to Queen Square from Red House gave Morris great scope to develop the Firm since he now lived more or less in the shop. In five months, between 1866 and 1867, the Firm carried out the redecoration of the Armoury and Tapestry Room at St James's Palace, a commission achieved through Rossetti. Then came the Green Dining Room commission in what is now the Victoria and Albert Museum (the V & A). This became the fashionable meeting place for intellectuals and men of taste in London, and more commissions followed from St James's Palace.

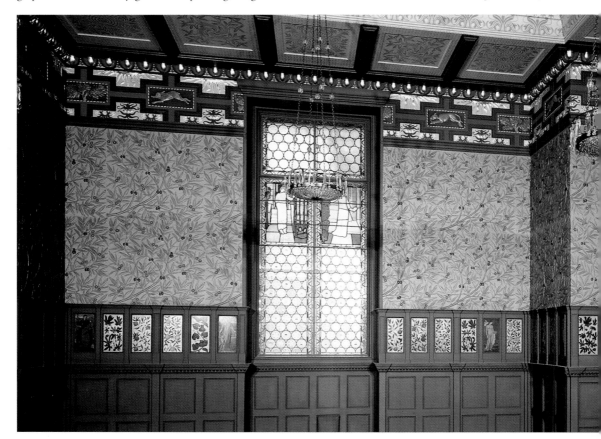

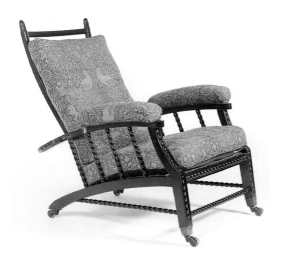

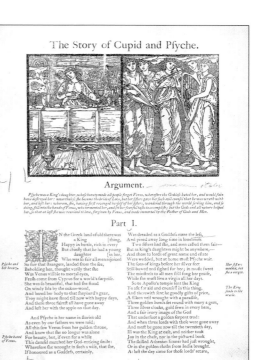

ABOVE:
An ebonised chair designed by Webb for the Firm, upholstered in original Bird woollen tapestry, 1878, now in the Victoria and Albert Museum, London.

LEFT:
The Green Dining Room in the V & A was one of the Firm's most important commissions.

ABOVE RIGHT:
A page from the section entitled 'Cupid and Psyche' of Morris's long poem *The Earthly Paradise* from the Pierpoint Morgan Library, New York.

RIGHT:
The spontaneity of Morris's Icelandic saga-writing is evident in this excerpt from his notes over Magnusson's literal translation, in the Brotherton Library, Leeds.

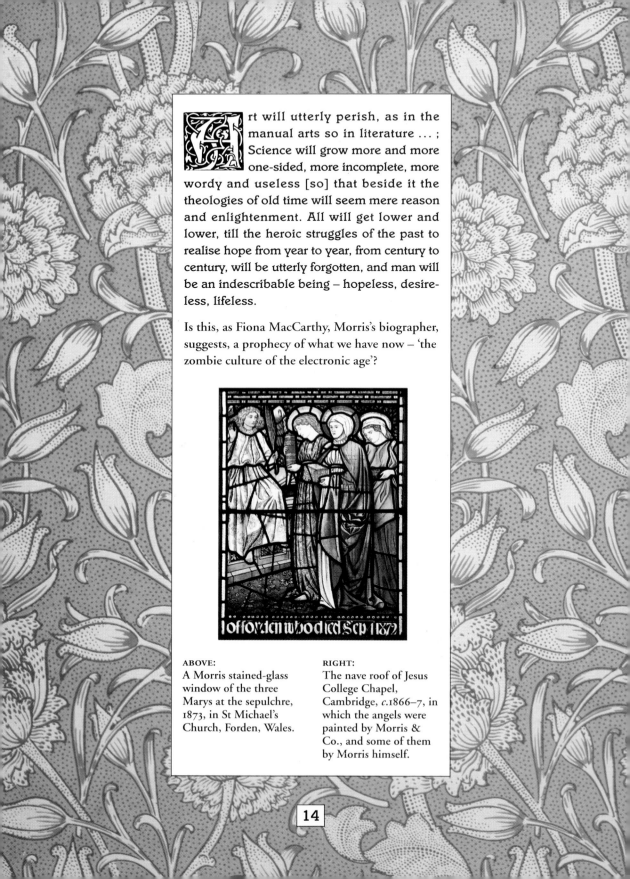

rt will utterly perish, as in the manual arts so in literature ... ; Science will grow more and more one-sided, more incomplete, more wordy and useless [so] that beside it the theologies of old time will seem mere reason and enlightenment. All will get lower and lower, till the heroic struggles of the past to realise hope from year to year, from century to century, will be utterly forgotten, and man will be an indescribable being – hopeless, desireless, lifeless.

Is this, as Fiona MacCarthy, Morris's biographer, suggests, a prophecy of what we have now – 'the zombie culture of the electronic age'?

ABOVE:
A Morris stained-glass window of the three Marys at the sepulchre, 1873, in St Michael's Church, Forden, Wales.

RIGHT:
The nave roof of Jesus College Chapel, Cambridge, c.1866–7, in which the angels were painted by Morris & Co., and some of them by Morris himself.

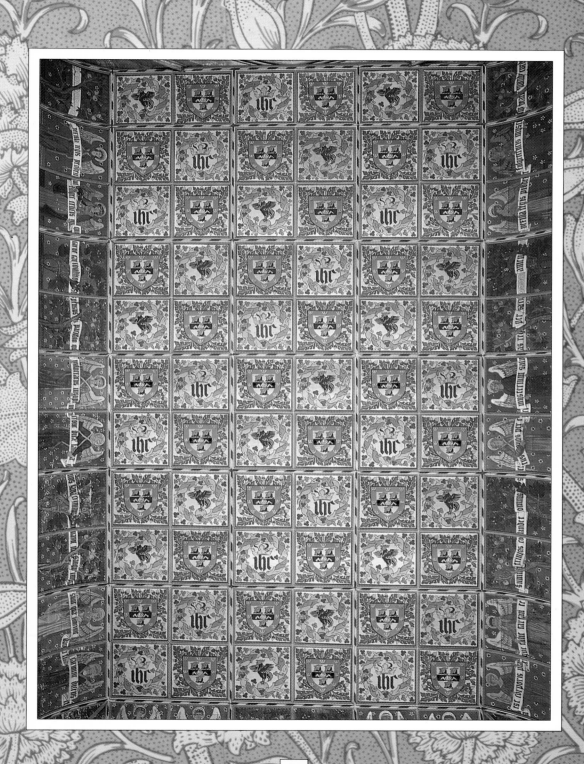

If a chap can't compose an epic poem
while he's weaving tapestry he had better shut up.

 eorge Wardle, the Firm's business manager for many years, worked with Morris and described him thus: 'His faculty for work was enormous and wonderfully versatile. He could turn his mind at once to the new matter brought before him and leave the poetry or the design without a murmur. How rapidly and accurately he wrote you know, almost without correction, page after page, but I may say that I always admired the easy way in which he turned from this ordinarily engrossing pursuit to attend to any other and resume his favourite work without apparently the loss of a single thread, as calmly as a workman goes to the bench after dinner.'

It seems almost as if Morris's life was a mirror of this facility for in effect doing two things at once. His wife urged him to find somewhere that she considered more suitable than the premises in Queen Square for her and the children, Jenny and May. In Oxfordshire he found Kelmscott Manor, 'at the very end of the village' and became very fond of it, although he rarely spent more than a few days at a time there. It was a rented property and the tenancy, taken on in 1871, was shared with Dante Gabriel Rossetti, who did spend a great deal of time there, with Janey and the girls. Mrs Morris later admitted that she never loved her husband, of which Morris must have been aware. The fact that he never overtly acknowledged this probably says more about the strength of character of this remarkable man than anything else.

Soon after taking Kelmscott Morris departed for the first of his two tours of Iceland, a country whose landscape and sagas (stories of heroic Icelandic figures from the 10th and 11th centuries) had a very deep and abiding effect on him. W. H. Evans was one of his companions and noted Morris's saga mentality: 'From the very first day that I began work with William Morris on Icelandic literature the thing that struck me most was this, that he entered into the spirit of it not with the preoccupied mind

of a foreigner, but with the intuition of an uncommonly wide-awake nature.' By the time of his first visit Morris had already, with Eiríkr Magnússon, an Icelandic scholar, completed prose translations of *Gunnlaugs Saga*, *Grettis Saga*, *Laxdæla Saga*, parts of the *Poetic Edda*, *Eyrbyggja Saga* and *Völsunga Saga*. Morris described this epic of the Volsungs as, *the Great Story of the North, which should be to all our race what the Tale of Troy was to the Greeks*. The handloom, part of the furniture of the Icelander's simple turf-walled farmer's cottage, was to resurface later in Morris's life when he made and installed one in his own bedroom and put it to very effective use.

During these early Kelmscott years one of Morris's most influential concepts began to surface – that of the

LEFT:
Morris translated and illuminated Icelandic stories, *c.*1873, which are now in the Fitzwilliam Museum, Cambridge.

RIGHT:
The Library or Drawing Room with Willow Bough wallpaper (1874) by William Morris in Carlyle's House, London. This paper was hand-printed for the Firm by Jeffrey & Co. It also decorates the wall of the visitors' staircase at Wightwick Manor, near Wolverhampton, a delightful National Trust property containing many of Morris's designs.

BELOW RIGHT:
Morris's design in pencil and watercolour for Tulip and Willow, 1873, in Birmingham Museum and Art Gallery.

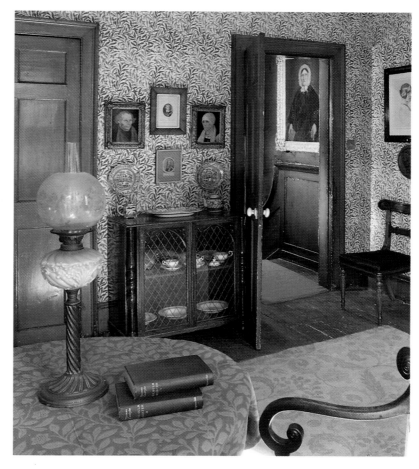

ideal of the network of small ruralist communities. He wrote, in his conversational way: *but look, suppose people lived in little communities among gardens and green fields, so that you could be in the country in 5 minutes walk, and had few wants; almost no furniture for instance, and no servants, and studied (the difficult) arts of enjoying life, and finding out what they really wanted: then I think one might hope civilization had begun.*

By 1874 the wealth Morris derived from share investments had diminished and the Firm was his only source of income; he did not feel that it adequately repaid the work he put into it and, indeed, he could hardly provide for his family. He wanted to make use of outside

manufacturers to produce wallpapers, chintzes and carpets designed by the Firm and thus to structure the business differently. This led to a lot of recriminations between the partners but eventually, on 31 March 1875 Morris, Marshall, Faulkner & Co. was formally dissolved and Morris & Co., under Morris's sole ownership, continued to trade. Morris, triumphant if disillusioned, wrote *I have got my partnership business settled at last, and am sole lord and master now.*

In 1875 Morris started to visit the town of Leek in Staffordshire, where he studied techniques of dyeing at Thomas Wardle's works (he was the brother-in-law of George Wardle, the Firm's manager). Morris was passionate about colour and dyeing: 'I never met a man who understood so much about colours' commented Thomas Wardle. Aniline dyes, derived from coal-tar, were in use in British textile factories at this time. *Of these dyes it must be enough to say that their discovery, while conferring the greatest honour on the abstract science of chemistry, and while doing great service to capitalists in their hunt after profits, has terribly injured the art of dyeing, and for the general public has nearly destroyed it as an art.*

Morris wanted a return to traditional dyestuffs for the four essential colours: blue from indigo; brown from walnut roots or shells; yellow from dye from wild mignonette; red from madder, cochineal or kermes. A letter of 1876 shows the obsession growing: *This morning I assisted at the dyeing of 20lbs of silk (for our damask) in the blue vat; it was very exciting, as the thing is quite unused now, and we ran a good chance of spoiling the silk. There were four dyers and Mr Wardle at work, and myself as dyers' mate: the men were encouraged with beer and to it they went, and pretty it was to see the silk coming green out of the vat and gradually turning blue: we succeeded very well as far as we can tell at present; the oldest of the workmen, an old fellow of seventy, remembers silk being dyed so, long ago. The vat, you must know, is a formidable-looking thing, 9 ft. deep and about 6 ft. square: and is sunk into the earth right up to the top. To-morrow I am going to Nottingham to see wool dyed blue in the woad vat, as it is called; on Friday Mr. Wardle is going to dye 80 lbs. more silk for us, and I am going to dye about 20 lbs. of wool in madder for my deep red.*

An intense interest in dyeing did not exclude other interests from Morris's life. In 1872 he was among the first of the designers when the Royal School of Needlework was founded 'to restore ornamented needlework for secular places to the high place it once held among the decorative arts'. The Leek School of Embroidery was founded

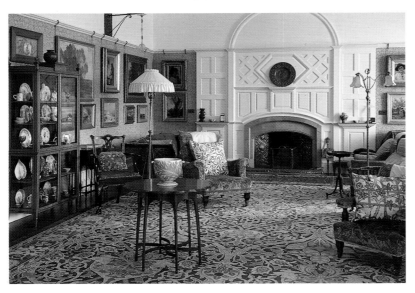

RIGHT:
The North Bedroom at Standen, a house designed by Philip Webb in 1892, shows Powdered wallpaper, 1874, a chair upholstered in Lodden, 1884, a Tulip and Lily carpet, c.1875, all designed by William Morris. The Firm supplied many of Standen's furnishings.

LEFT:
A hand-knotted William Morris carpet in the Drawing Room at Standen.

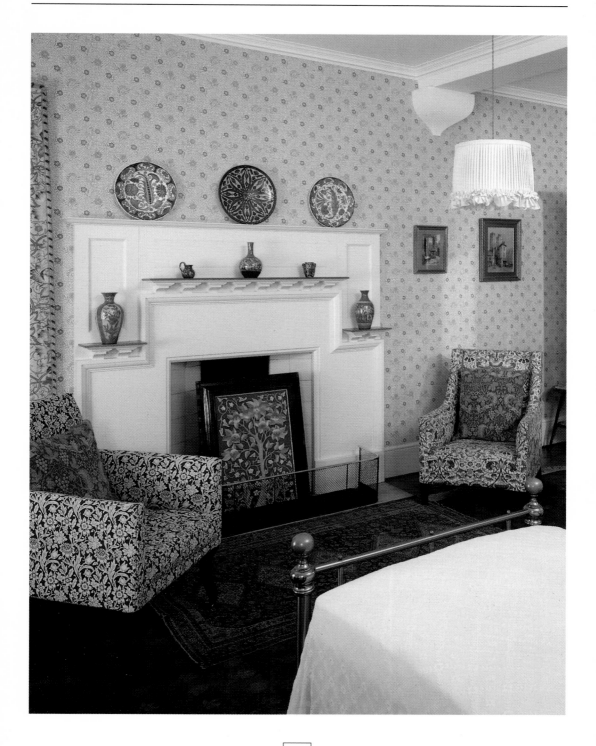

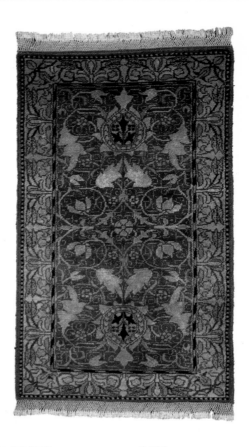

in 1879 or 1880 as a direct result of his interest. In addition, an African marigold design for a printed linoleum called 'Corticine floor cloth' was registered in 1875, along with Morris's first designs for machine-made carpets made by outside manufacturers. Morris's ultimate aim was *to make England independent of the East for the supply of hand-made carpets which may claim to be considered works of art.*

In 1876 a boating accident apparently triggered epilepsy in Morris's beloved and gifted daughter, Jenny. This condition at that time rendered the sufferer unable to cope with normal conditions of life. This was a severe blow to Morris, whose 'concern for Jenny gave him new perceptions of wider social distress and injustices and the urge to move society on beyond the reach of them' (MacCarthy).

In 1877 silk weaving was set up in Queen Square. At the same time Morris was becoming proficient in hand-knotting rugs and carpets and he wanted to set up a loom for brocade weaving. Enthusiasm was not lacking: *I am writing in a whirlwind of dyeing and weaving, and even as to the latter rather excited by a new piece just out of the loom, which looks beautiful, like a flower garden.*

ABOVE LEFT:
A floral design in pencil and watercolour, that Morris made in 1874–5 for the Oxford Union Ceiling to replace his original which he did not like. The design is now at Kelmscott House, Hammersmith.

ABOVE:
Hammersmith rug, c.1880, designed by Morris and one of many rugs woven at Kelmscott House, Hammersmith. This is probably a late weaving of an earlier design; it has a wool pile on cotton warp.

RIGHT:
Morris's floral tile panel of 1876, designed by him and made in 1877 by William de Morgan for Membland Hall, Devon. Now in the William Morris Gallery, Walthamstow.

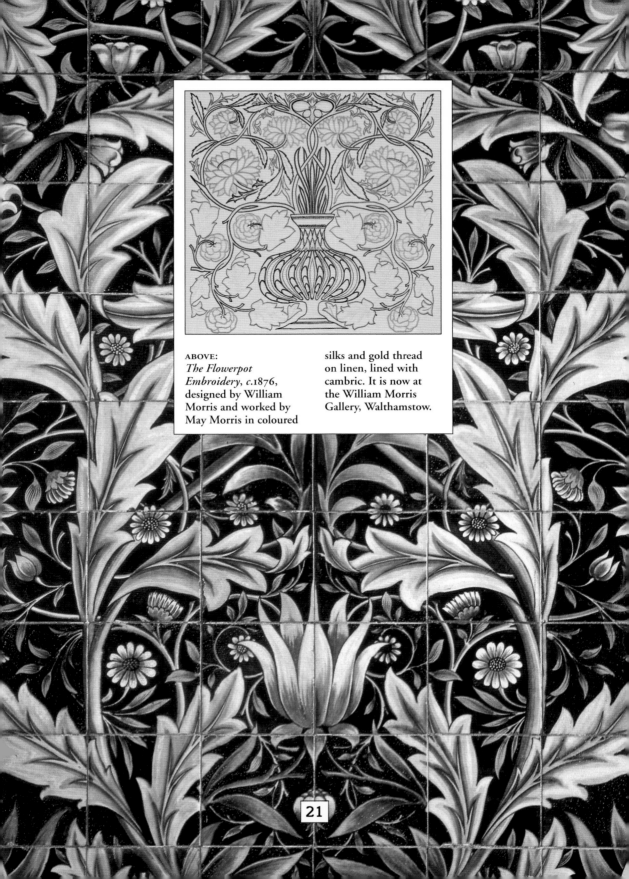

ABOVE:
The Flowerpot Embroidery, c.1876, designed by William Morris and worked by May Morris in coloured silks and gold thread on linen, lined with cambric. It is now at the William Morris Gallery, Walthamstow.

First, it would scarcely take one longer to get there from Hammersmith than it does now to Queen Sq: next it is already a print-works (for those hideous red and green table cloths and so forth) so that the plant would be really useful to us: 3rd the buildings are not bad: 4th the rent (£200) can be managed, if we can settle all that, as at present what is offered for sale is the tail-end of a lease and the plant. 5th the water is abundant and good. 6th though the suburb as such is woeful beyond conception, yet the place itself is even very pretty: summa, I think it will come to taking it, if we can get it on fair terms.

In 1881 the seven-acre site at Merton Abbey became the home for Morris & Co., which lasted until shortly after the outbreak of the Second World War. William de Morgan, the brilliant potter whom Morris had known since Red Lion Square days, and with whom he now shared an involvement in the SPAB (Society for the Protection of Ancient Buildings), found a separate site there where he could make his ceramic tiles and pots.

The dyeing, weaving and stained glass produced during the Merton Abbey years continued even after Morris's great conversion to, or revelation of, the Socialist cause, in 1883. He had put work in hand and it continued to be done. Nineteen textile patterns were registered by Morris & Co. between 1882 and 1885; they included Rose and Thistle, Bird and Anemone, Brother Rabbit and those named after tributaries of the Thames – Windrush, Evenlode, Kennet, Wey, Wardle and Medway. He was anxious to produce cheaper fabrics so *even the humble can indulge in simple articles.* But the nearest this came to happening was when Laura Ashley started to mass-produce her designed fabrics in the 1960s. Morris was unable to lower the price of his goods enough for the humble to buy without lowering the quality.

Factory visits for prospective customers proved very successful for tapestry production at Merton. Curiosity about the unusual technique employed (using medieval-style high-warp looms) and the enormous scale of many of the tapestries aroused interest in them.

BELOW:
A woodblock for Chrysanthemum wallpaper now held by Sanderson. They hold nearly 100 of the original woodblocks from which special makings of papers and fabrics can be produced if required.

RIGHT:
Kennet Silk Damask, 1883, designed by Morris and woven at Merton Abbey. It is now in the Whitworth Art Gallery, Manchester.

RIGHT, INSET:
Woodpecker Tapestry, woven on a medieval-style high warp loom at Merton Abbey, in 1885. Designed by Morris, it is now in the William Morris Gallery, Walthamstow.

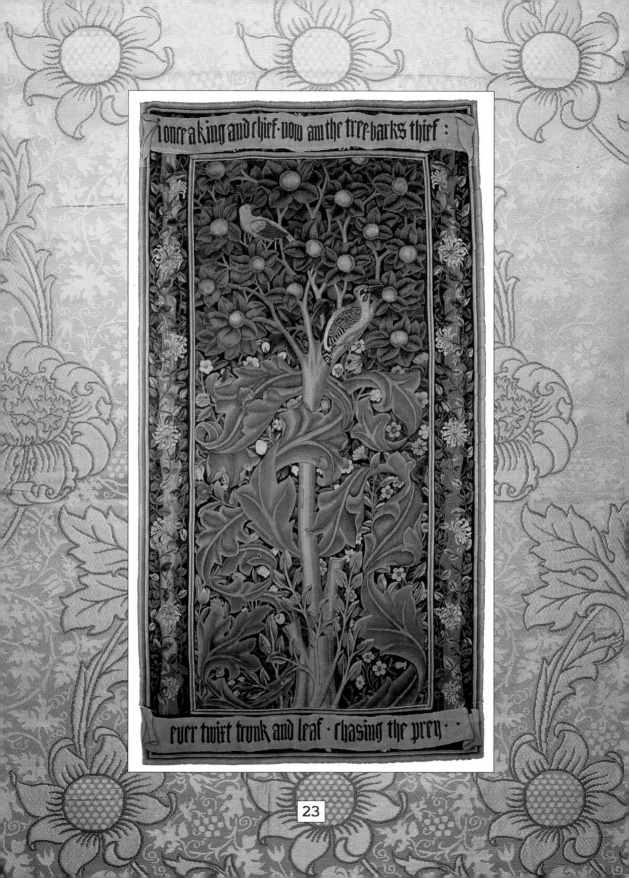

It was the essence of my undertaking to produce books which it would be a pleasure to look upon as pieces of printing and arrangement of type.

o we not still aspire to these standards today? It would be difficult to improve on them. William Morris had always been fascinated by the skill of the medieval craftsmen who produced beautiful illuminated books, and he was especially attracted to their typographic excellence which he felt was so superior to that produced in his own age. Accordingly, on 12 January 1891, he rented the first premises to house the Kelmscott Press, named after his beloved Kelmscott Manor in Oxfordshire. Morris the printer also became a typographer: the first type he designed for the Press was 'Golden'.

What I wanted was letter pure in form; severe, without needless excrescences; solid, without the thickening and thinning of the line, which is the essential fault of ordinary modern type, and which makes it difficult to read; and not compressed laterally, as all later type has grown to be owing to its commercial exigences.

Fiona MacCarthy describes Morris's two principles that had great influence on 20th-century typographic practice. 'The first was that the text should be set with close spacing, forestalling *"ugly rivers"* of white, formed by too loose a disposal of letters, running vertically down the page. Morris's other principle concerns what he calls *"the position of the printed matter on the page"* which should revert to the mediaeval rule in leaving the inner margin the narrowest, the top *"somewhat wider"*, the outside edge wider still and the bottom widest of all. In proposing that *"the unit of a book"* was not just one page but a pair of pages, what would now be called a double-page spread, Morris was consciously challenging contemporary practice. The two opposite pages must be visually balanced; illustration and ornament must be carefully considered in relation to the text. Morris writes, *"It is only natural that I, a decorator by profession, should attempt to ornament my own books suitably".*'

BELOW:
Morris illuminated this page on vellum of *The Odes of Horace*, 1874, now in the Bodleian Library, before he set up the Kelmscott Press.

RIGHT:
Frontispiece to *News from Nowhere*, 1892, printed at the Kelmscott Press in Morris's 'Golden' type.

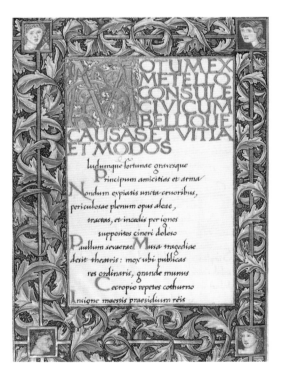

The decoration was also very important to Morris and an observer who saw him working on a border for the Press wrote: 'There were two saucers, one of Indian ink and the other of Chinese white, and two brushes; with one brush he blacked over a length of border, and then with the other began to paint in the stems and leafage of his pattern, solving all the problems of the twists and turns as he came to them.'

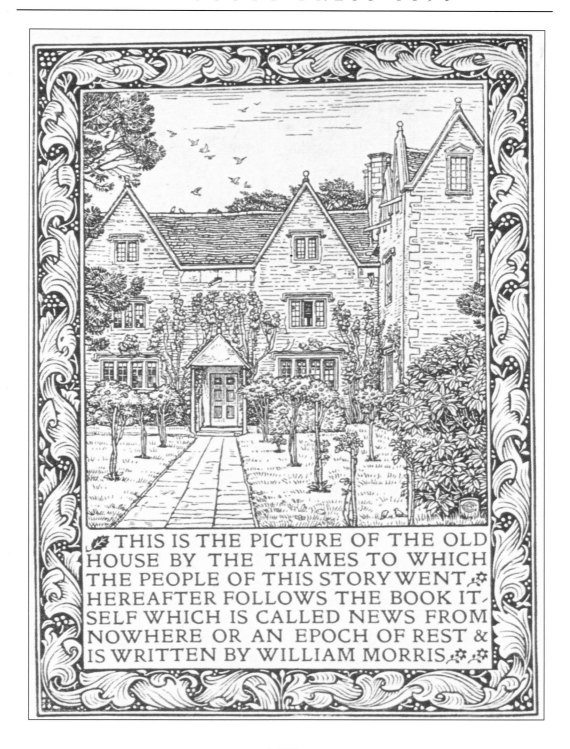

THIS IS THE PICTURE OF THE OLD HOUSE BY THE THAMES TO WHICH THE PEOPLE OF THIS STORY WENT. HEREAFTER FOLLOWS THE BOOK ITSELF WHICH IS CALLED NEWS FROM NOWHERE OR AN EPOCH OF REST & IS WRITTEN BY WILLIAM MORRIS.

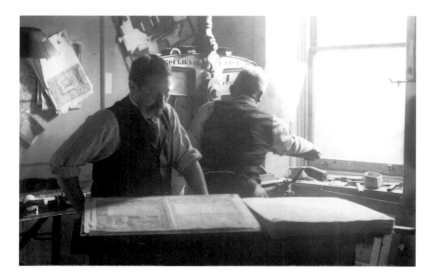

LEFT:
The press-room at Kelmscott House showing the Chaucer being printed on Albion Press No.6551.

BELOW LEFT:
A page from the Kelmscott *Chaucer* depicting 'The Tale of the Wife of Bath'.

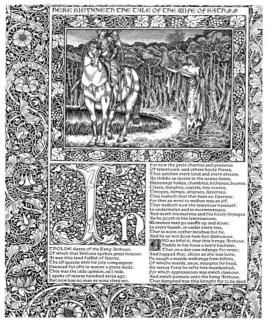

In the midst of this absorbing activity Morris's daughter, Jenny, had a sudden attack of meningitis. Janey wrote to a friend, 'My husband has been very ill, the shock of Jenny's illness was too much for him, and he broke down entirely a few days afterwards ... I fear it will be a long time before he is anything like his real self.'

Despite this, Morris continued writing and publishing until weeks before his death on 3 October 1896. It is interesting to note the tributes paid to him by contemporary newspapers; he was remembered primarily as a writer.

'A poet, and one of our half dozen best poets, even when Tennyson and Browning were still alive,' *The Times*.

' ...the most genuine master of poetry who remained amongst us,' *The Daily News*.

Except in the Socialist press, which was united in its grief, his politics were belittled and had scorn poured on them. But the Icelandic paper Bjarki seems to have provided one of the most moving tributes:

William Morris, one of the most famous poets of England, is reported to have died on the 3rd of this month. He travelled around Iceland, loved everything Icelandic, and chose material for his poetry from several of our sagas, such as 'Laxdæla', 'Völsunga', etc. He was a great freedom lover, a dedicated socialist and a most outstanding man.

SOME WILLIAM MORRIS CONNECTIONS

c Ceramics/tiles
D Decoration
F Furniture
G Stained glass
K Kelmscott Press
M Manuscripts
P Painting
T Textiles

This list is not exhaustive. Morris's influence touched many more buildings, churches and places than can be mentioned here.

Avon
Holburne Museum, Bath (Arts and Crafts)

Berkshire
T Eton College Chapel, Eton,

Cambridgeshire
G Ely Cathedral
M Fitzwilliam Museum, Cambridge
D Jesus College Chapel, Cambridge
c, G Peterhouse, Cambridge
c Queens' College Hall, Cambridge

Cornwall
Llanhydrock, Bodmin (National Trust)

Cumbria
G Brampton; Brantwood, Coniston; Lanercost Priory; Troutbeck

Devon
G Tavistock; St John, Torquay

Durham
G St Oswald, Durham

Gloucestershire
F Cheltenham Art Gallery

Greater Manchester
P Manchester City Art Gallery
T Whitworth Art Gallery

London
M British Library
Carlyle's House (National Trust)
Kelmscott House, Hammersmith (headquarters of the William Morris Society)
T Liberty, Regent Street
William Morris Gallery, Walthamstow (Housed in Morris's childhood home it contains a comprehensive display of his work in all media.)
T Sanderson, Knightsbridge
P Tate Gallery
Victoria and Albert Museum

Merseyside
D Speke Hall (National Trust)

Northamptonshire
G Peterborough Cathedral

Oxfordshire
P, F Ashmolean Museum, Oxford
c, M Bodleian Library, Oxford
P Buscot House, Buscot (National Trust)
G Christ Church Cathedral, Oxford
T Exeter College Chapel, Oxford
The Great Barn, Coxwell (National Trust)
Kelmscott Manor, Kelmscott
G Manchester College Chapel, Oxford
D Oxford Union, Oxford
G St Edmund Hall Chapel, Oxford

Sussex
Standen, East Grinstead (National Trust)

West Midlands
T, M Birmingham City Art Gallery
Wightwick Manor (National Trust)

Wiltshire
Wilton Carpet Factory

Yorkshire
M Brotherton Library, Leeds

Wales
G Llandaff Cathedral, South Glamorgan
G St Michael's Church, Forden, Powys
Penrhyn Castle, Gwynedd (National Trust)

Scotland
G King's College Chapel, Aberdeen
G Paisley Abbey, Strathclyde

Ireland
Mount Stewart House, Co. Down (National Trust)

Books on William Morris, the Pre-Raphaelites and the Arts and Crafts movement are listed in catalogues from Victor Adams, 55 Keyford, Frome, Somerset BA11 1JT.

PERSONALITIES AND SOCIETIES

ARTS AND CRAFTS MOVEMENT Morris believed that design and craftsmanship were an integral part of human self-expression and fulfilment and that a decent society would reflect this.

FORD MADOX BROWN (1821–93) Painter associated with Pre-Raphaelite Brotherhood and founder member of the Firm.

ROBERT BROWNING (1812–89) Poet who influenced Morris's early poems, especially *The Defence of Guenevere*.

SIR EDWARD (NED) COLEY BURNE-JONES BT. (1833–98) Painter whom Morris met at Exeter College, Oxford and who was a founder member of Morris, Marshall, Faulkner & Co.; designed most of the figures for stained glass and tapestries and produced illustrations for the Kelmscott Press.

WALTER CRANE (1845–1915) Painter and illustrator and a friend of Morris, sharing his political views and producing drawings for the Kelmscott Press.

WILLIAM DE MORGAN (1839–1917) Self-taught and well-known ceramicist of the Arts and Crafts movement who produced tiles and lustre-ware. Worked for the Firm and in 1882 moved workshops to Merton Abbey.

W.H. EVANS The fourth member of Morris's trip to Iceland that included Magnússon and Faulkner.

C.J. FAULKNER (1834–92) Mathematician and lifelong friend of Morris from the Oxford 'set' and founder member of the Firm.

THE FIRM (1861–1940) The name originally given to Morris, Marshall, Faulkner & Co. and continued from 1875 to apply to Morris & Co.

WILLIAM FULFORD (1832–97) Member of the Oxford 'set'.

ARTHUR HUGHES (1832–1915) Pre-Raphaelite painter associated with Oxford Union Mural scheme.

JEFFREY & CO. Wallpaper manufacturer in Islington; printed Morris's wallpapers from 1864.

LEEK SCHOOL OF EMBROIDERY Founded 1879/80 by Thomas Wardle's wife, with encouragement from Morris.

ARTHUR LASENBY LIBERTY (1843–1917) Opened Liberty & Co., Regent Street in 1875 selling fashion, fabrics, metalwork, furniture, carpets and pottery. Its aim was to raise public awareness of fashion and design and its products were extremely successful. However, it diverged from the ideals of the Arts and Crafts movement by commercialising progressive design of the 1890s/1900s.

FIONA MACCARTHY Author of Morris's biography, *William Morris: A Life for Our Time*, 1994, Faber & Faber.

EIRÍKR MAGNÚSSON (1833–1913) Taught Morris Icelandic, helped him in translations and accompanied him to Iceland.

P.P. MARSHALL Friend of Ford Madox Brown and partner of the Firm but never very active in its work.

MORRIS & CO. (1875–1940) On 31 March 1875 Morris, Marshall, Faulkner & Co. formally dissolved and business continued under Morris's sole ownership, as Morris & Co.

JANE (JANEY) MORRIS, NÉE BURDEN (1839–1914) Married Morris in 1859, produced embroidery for the Firm, and was the paramour of Dante Gabriel Rossetti, whose many drawings and portraits have made her features familiar.

JANE ALICE (JENNY) MORRIS (1861–1935) Morris's elder daughter whose childhood was filled with a promise that was thwarted by the onset of severe epilepsy in 1876.

MORRIS, MARSHALL, FAULKNER & CO. (1861–75) See p.7 for members' names and aspirations.

MARY (MAY) MORRIS (1862–1938) Morris's younger daughter was given charge of the Firm's embroidery section from 1885. She shared her father's political commitment and edited his *Collected Works* after his death.

WILLIAM MORRIS SENIOR (1797–1847) Morris's father, whose investment in Devon Great Consols provided well for his family for several years after his death.

PRE-RAPHAELITE BROTHERHOOD Founded 1848 by William Holman Hunt, John Millais and D.G. Rossetti, who was its 'mind and soul' and believed in painting from nature and that art, design and literature have a common creative base. By the 1850s original members had dispersed and